CUTE KAWAII
DOODLES

CUTE KAWAII DOODLES

100 super-cute characters to draw
using only a ballpoint pen

Sarah Alberto

Abrams, New York

Printed and bound in China
10 9 8 7 6 5 4 3 2 1

Abrams Noterie products are available
at special discounts when purchased in
quantity for premiums and promotions
as well as fundraising or educational
use. Special editions can also be
created to specification. For details,
contact specialsales@abramsbooks.com
or the address below.

ABRAMS The Art of Books
195 Broadway, New York, NY 10007
abramsbooks.com

ISBN: 978-1-4197-3242-3

For Abrams:

Editor: Bridget Waterhouse
Cover Design: Hana Anouk Nakamura
Design Managers: Hana Anouk
Nakamura and Katie Benezra
Production Managers: Denise LaCongo
and Alison Gervais

Conceived, edited, and designed by
Quarto Publishing plc, an imprint of
The Quarto Group
6 Blundell Street
London N7 9BH

CONTENTS

MEET SARAH

Hi! My name is Sarah. I am a freelance illustrator and stay-at-home mom from Sydney, Australia. Art has always been a passion of mine, but it wasn't until 2015 that I started to take it more seriously and embarked upon a YouTube channel under the pseudonym Doodles by Sarah.

As I became more active online, my love for arts and crafts grew. I was switching from planner to planner and trying out different kinds of scrapbooking, such as Project Life and mixed media art. After that, I tried out art journals and even exchanged snail mail with my fellow stationery enthusiasts.

It was when I started doodling on my planner that I received a lot of attention. I thought that it was more reasonable to just draw on my planner instead of buying stickers and stamps to decorate it, and my followers seemed to agree. So, I decided to stick with it and upload the content to my YouTube channel as "doodle tutorials." All my ideas for my videos are inspired by my children and my subscribers, who are always supporting my art and suggesting new things for me to draw.

My doodling journey has only just begun and I am excited to learn new things as I go, as well as collaborate with other people who are passionate about arts and crafts.

MATERIALS I USE

TOOLS FOR DOODLING

SARASA GEL PEN (BLACK)
For doodling my super-cute characters, my favorite tool to use is the ballpoint pen—in particular, the gel pen. Ballpoint pens are universal, affordable, and versatile and allow you to create small details and sharp lines. Just like fine liners, ballpoint pens come with different nibs—my favorites being 0.5, 0.7, and 0.38.

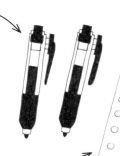

PENCIL
All of the doodles in this book are designed to be really simple, but, if you are ever feeling unsure of your abilities, it's always best to start off your sketch with a pencil. Then, if you make a mistake, you can easily erase it and start over again.

PAPER
I am a big fan of using gridded paper as the lines serve as a guide. However, feel free to use whatever kind of paper you like—there is plenty of blank space in this book for you to practice on.

TOOLS FOR COLORING

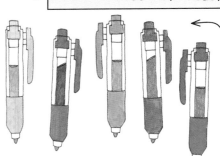

SARASA GEL PENS
Gel pens come in many different shades and colors. I use these to color most of my drawings as they give a hand-drawn feel to my art.

CRAYOLA SUPER TIPS WASHABLE MARKERS
Looking for affordable markers? These ones are perfect! They come in up to 50 different colors and they don't bleed through paper.

FABER–CASTEL PITT ARTIST PEN
Another favorite of mine! These brush pens are great for both coloring in and drawing.

SAKURA GELLY ROLL
I often use white gel pens to add more detail to some of my drawings.

TOMBOW DUAL BRUSH PENS
If you want to invest in good-quality markers for drawing or lettering, Tombow pens are perfect. In this book, I used the gray a lot for shadowing and detail work.

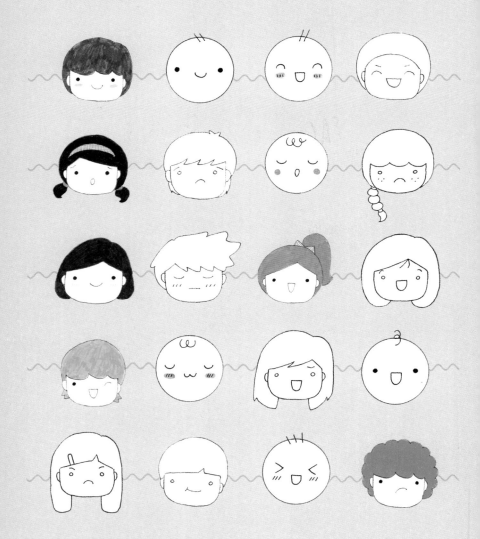

FACES AND PEOPLE

These different doodle expressions are
made up of simple lines and shapes that
are as easy as 1-2-3!

In this chapter, I will show you how I draw
cute faces by combining dots and lines to
create several looks. And let's not forget
to add some hair!

BECAUSE I'M HAPPY

Changing up features such as the eyebrows and mouth gives each face a different expression.

NOW
DRAW IT!

WHAT
MOOD
ARE
YOU IN
TODAY?

EXPRESS YOURSELF

Drawing a shape similar to a smiling mouth above the eye gives your character a confused look.

YOUR GO!

Colored lines added to the cheeks give this guy a sense of shame.

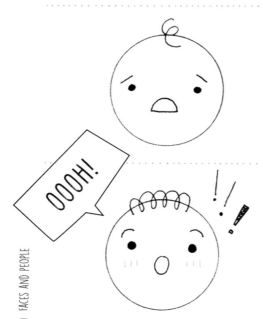

YOUR
GO!

SMILEY FACE

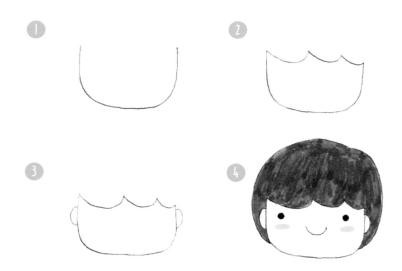

PULLING FACES

This guy doesn't look too pleased— he can't tame his curly mane!

YOUR
TURN!

NOT A HAIR OUT OF PLACE

Create a round shape for a sleek and smooth hairdo.

He's not impressed with his bangs!

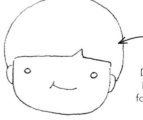

Draw a straight line across the forehead to alter the hairline.

COME UP
WITH YOUR
OWN COOL
HAIRSTYLE!

FACE VALUE

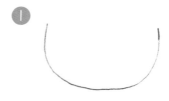

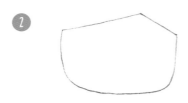

NOT JUST A PRETTY FACE

HAVE
A GO!

GOOD HAIR DAY

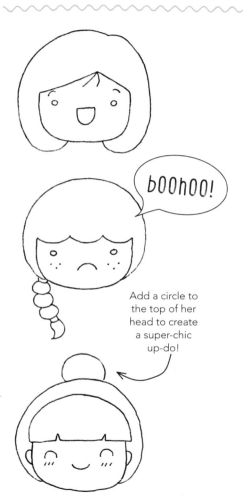

boohoo!

Add a circle to the top of her head to create a super-chic up-do!

HOW DO YOU WEAR YOUR HAIR?

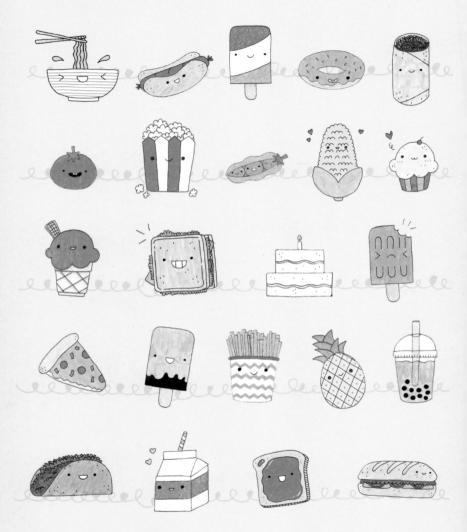

FOOD

Food is one of my favorite subjects to draw—after all, who doesn't like food?

In this chapter, I will show you how to draw tasty treats, such as pizza, popcorn, and popsicles, in six easy steps or less!

Once you've got the basic shapes down, you can add color and cute faces to your doodles to give them character and make them look even more scrumptious!

BURRITO

 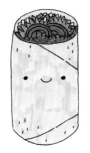

YOUR TURN!

LET THEM EAT CAKE

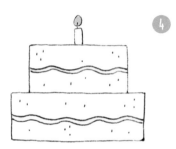

DIFFERENT DESSERTS

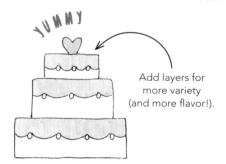

YUMMY

Add layers for more variety (and more flavor!).

NOW DRAW IT!

CORN ON THE COB

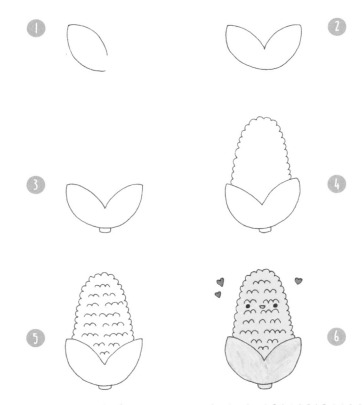

DELICIOUS DONUT

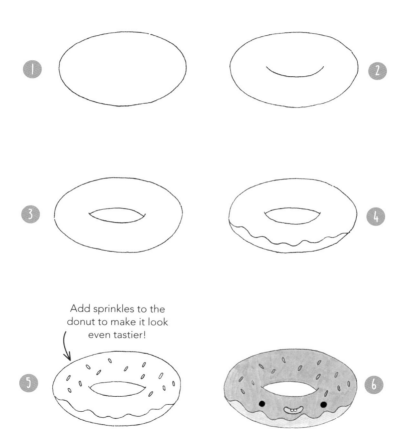

Add sprinkles to the donut to make it look even tastier!

COFFEE HIT

○ ○

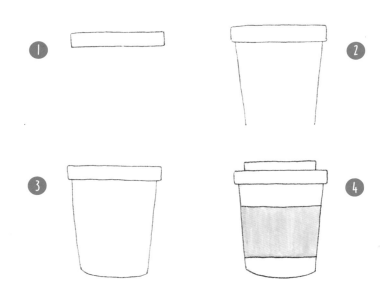

DRINK UP!

Add a straw to create a paper cup full of your favorite soda.

SLURP

Draw a clear container so you can see its contents.

○ ○

NOW DRAW IT!

Follow the steps opposite or try one of the options below for a different, but equally delicious drink.

FRIES BEFORE GUYS

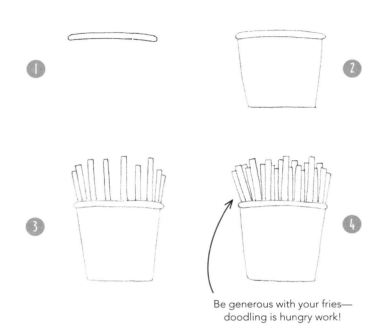

1

2

3

4

Be generous with your fries—
doodling is hungry work!

5

NOW DRAW IT!

JUICY FRUITS

Add small circles for the strawberry's seeds.

Drawing a face on your fruit creates that cute kawaii element.

DOODLE THE
INGREDIENTS OF
YOUR FAVORITE
FRUIT SALAD!

HAPPY HAMBURGER

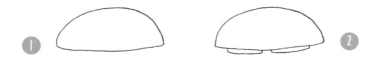

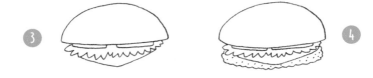

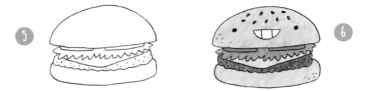

HAVE A GO!

HOT—DIGGITY—DOG

Add curved lines
to make your
sausage sizzle!

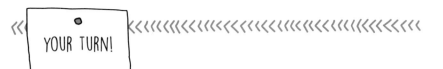

YOUR TURN!

WE ALL SCREAM FOR ICE CREAM

The main ice cream shape looks like a fluffy cloud. Use it to create a variety of ice cream doodles!

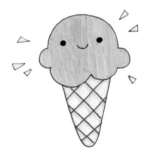

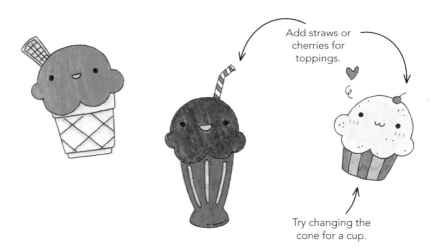

Add straws or cherries for toppings.

Try changing the cone for a cup.

DRAW YOUR MOST DELICIOUS DESSERT!

TASTY TOMATO

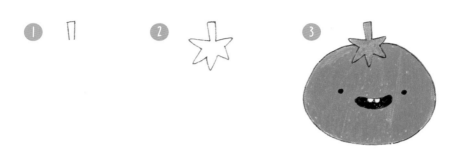

VERY CUTE VEGGIES

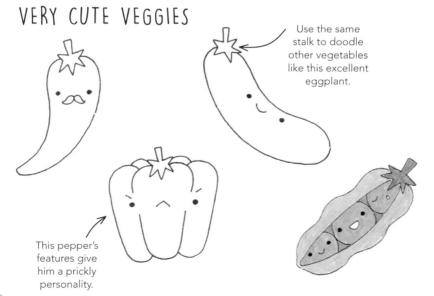

Use the same stalk to doodle other vegetables like this excellent eggplant.

This pepper's features give him a prickly personality.

TEST OUT YOUR VEGGIE SKILLS!

NOM NOM, NOODLES

Simple shapes build up to make the container for your noodles.

1

2

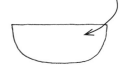

3

4

5

6

GET TO
GRIPS WITH
NOODLES AND
CHOPSTICKS!

PRICKLY PINEAPPLE

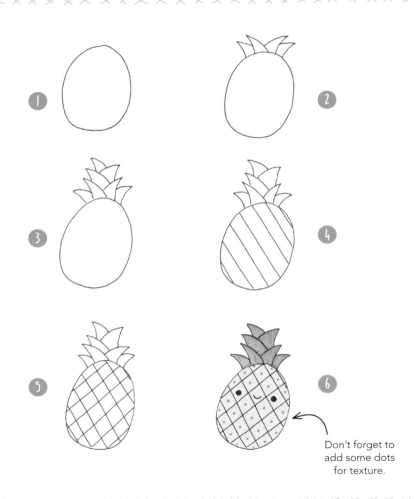

Don't forget to add some dots for texture.

PIZZA PARTY

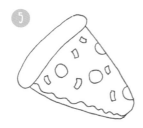

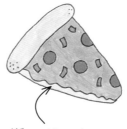

Why not try out different tasty toppings?

NOW
DRAW
IT!

POPPING POPCORN

1

2

3

4

5

6

ICE—COLD ICE POP

FROZEN FRIENDS

Take a bite out of this popsicle to give him brain freeze.

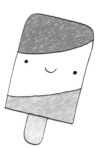

TAKE A POP AT
DOODLING YOUR
FAVORITE POPSICLE!

SUPER SANDWICH

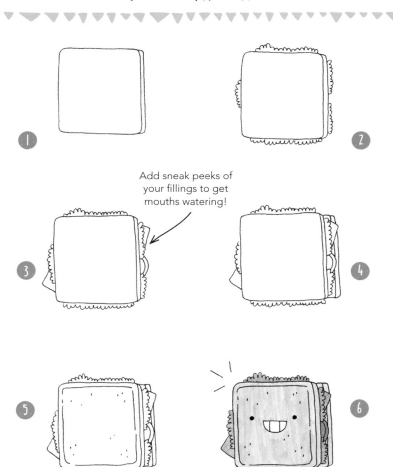

Add sneak peeks of your fillings to get mouths watering!

HAVE
A GO!

BREAD WINNERS

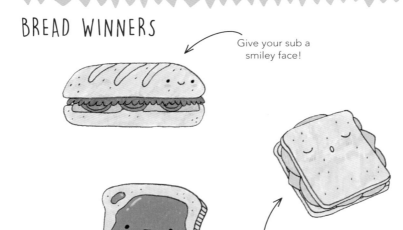

Give your sub a smiley face!

Add your favorite fillings.

PREPARE A
SANDWICH FOR
YOUR PACKED
LUNCH.

TASTY TACO

Add dots to your filling to create texture.

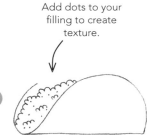

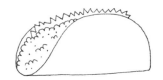

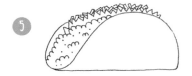

TRY IT YOURSELF!

MILK IT

 1

 2

3

 4

 5

 6

NOW IT'S
YOUR
TURN!

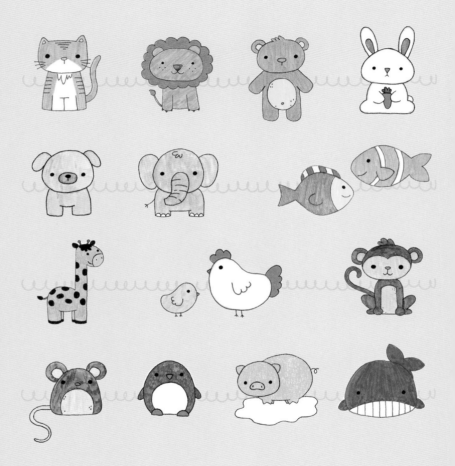

ANIMALS

Animals come in all sorts of shapes and sizes, colors, and patterns. Here, I share with you very easy steps on how to draw some of my favorite animals—from an ordinary house cat to the king of the jungle! And of course, I will be adding a sprinkle of kawaii to each and every one.

CATS

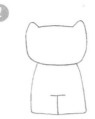

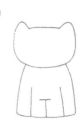

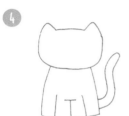

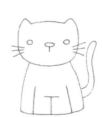

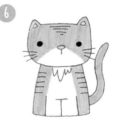

CUTE KITTENS

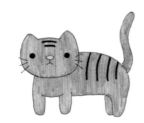

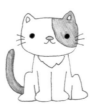

Use the same-shaped head to draw different kinds of cats standing, sitting, or sleeping.

NOW DRAW IT!

Follow the steps opposite or try drawing your very own kitty.

KING OF THE JUNGLE

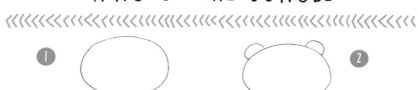

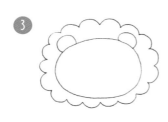

BEAR HUG

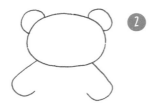

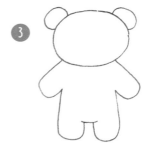

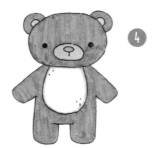

MANY BREEDS OF BEAR

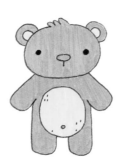

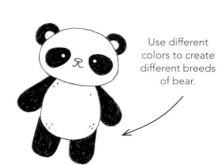

Use different colors to create different breeds of bear.

BUNNY HOP

1

2

3

4

ALL EARS

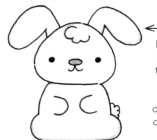

← Play around with the bunny's ears—draw them standing up to show whether your character is alert or droopy, to give it that cute and floppy look.

A DOG'S LIFE

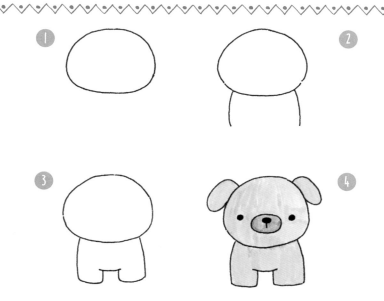

A DIFFERENT BREED

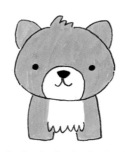

Draw different breeds of dogs by changing up the shape of the ears, nose, and mouth.

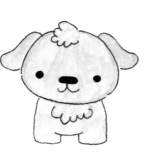

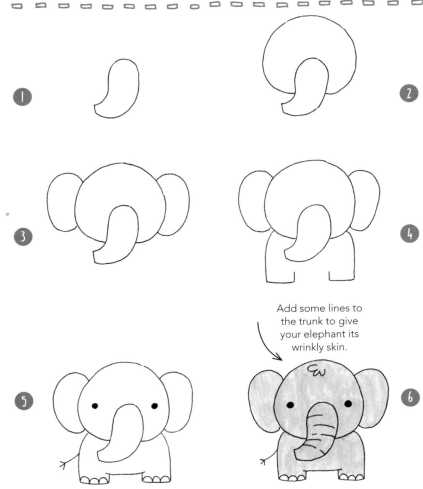

Add some lines to the trunk to give your elephant its wrinkly skin.

FISHING FOR COMPLIMENTS

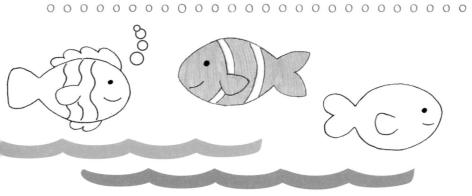

NOW DRAW IT!

There are plenty of fish in the sea. Draw your favorite here!

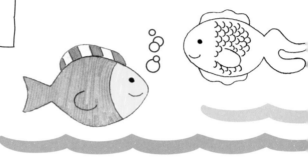

GRACEFUL GIRAFFE

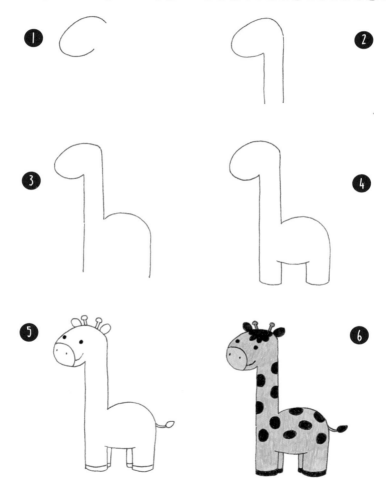

MOTHER HEN

1

Draw a jellybean shape for the bodies of both mother and chick.

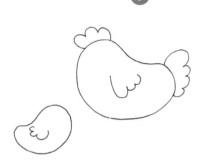

2

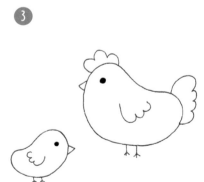

3

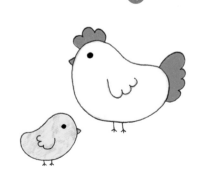

4

CHEEKY MONKEY

1

2

3

4

5

6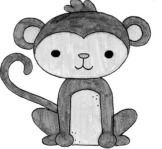

MESS ABOUT
WITH YOUR
MONKEY
DOODLES!

QUIET AS A MOUSE

1

2

3

4

5

6

PLUMP PENGUIN

 1

2

3

4

5

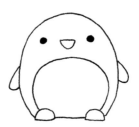

6

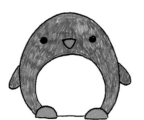

PORKY PIG

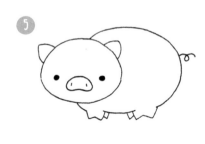 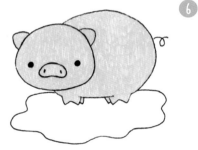

A WHALE OF A TIME

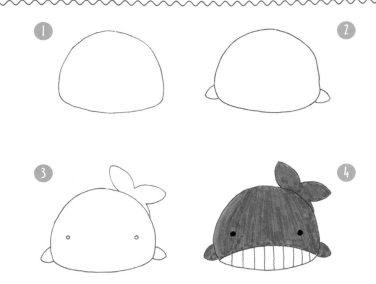

FRIENDLY FACES

Change the face of your sea creature to create a dolphin or an orca!

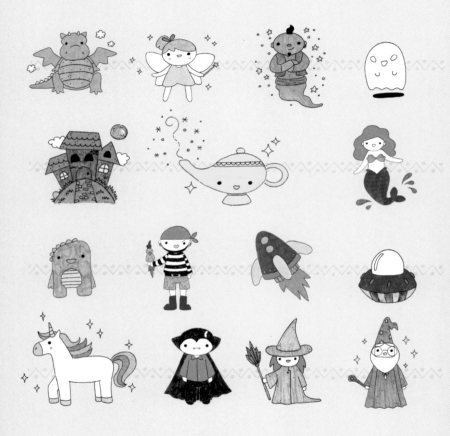

FANTASY

The key to drawing unique characters and objects is to use your imagination. In this chapter, I will show you how to draw simple, make-believe characters, such as a unicorn, a genie, a mermaid, and a wizard. Feel free to personalize your doodles—why not give your witch a wand to cast her spells?

THE MAGIC DRAGON

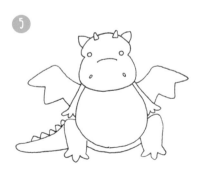

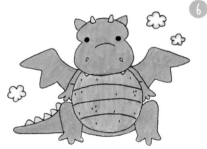

YOUR FAIRY GODMOTHER

Give your fairy spell-casting abilities by adding in a wand, complete with stars and sparkles.

YOUR TURN!

GENIE IN A BOTTLE

Fold the genie's arms to give him the authority he needs to grant all those wishes.

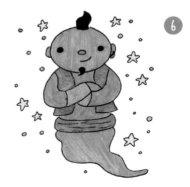

GHOST TOWN

HAVE A GO!

HELLO!

HAUNTED HOUSE

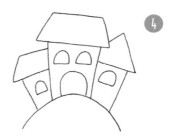

FANTASY

DRAW MORE
HAIR-RAISING HOUSES HERE!

ALADDIN'S LAMP

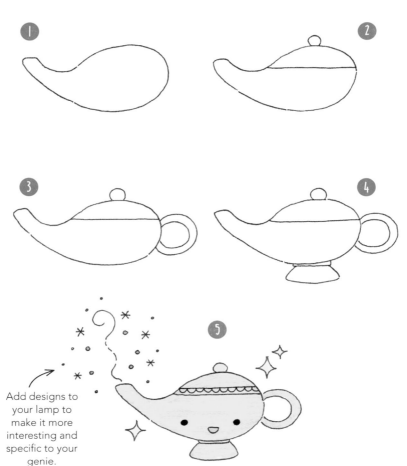

Add designs to your lamp to make it more interesting and specific to your genie.

NOW
DRAW IT!

THE LITTLE MERMAID

TRY IT
YOURSELF!

MONSTER MASH

CREATE YOUR VERY OWN CREEPY CREATURES!

YIKES!

A PIRATE'S LIFE FOR ME

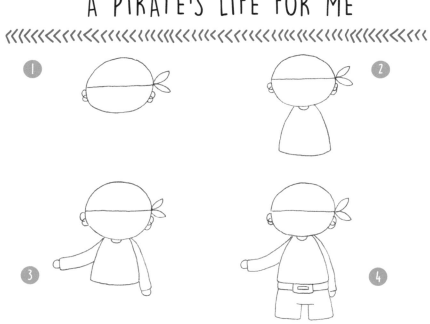

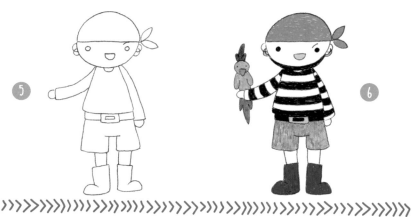

HAVE A GO!

BLAST OFF!

× ×

 1

 2

3

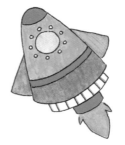 **4**

..

TAKE FLIGHT

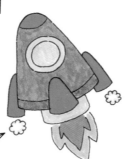

Plumes of smoke show that this rocket's engine is running to full capacity.

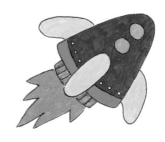

× ×

NOW DRAW IT!

OUT OF THIS WORLD

 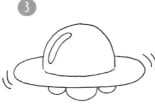

SUPER SPACESHIPS

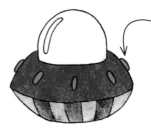 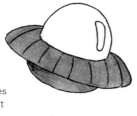

Different shapes create different bodies for your UFOs.

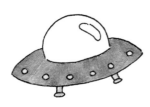

NOW IT'S
YOUR TURN!

OTHERWORLDLY UNICORN

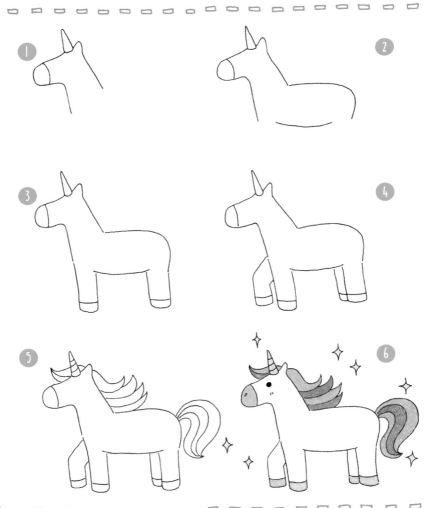

PERSONALIZE YOUR
UNICORN BY GIVING
IT DIFFERENT—
COLORED HAIR

VAMPIRE

1.

2

3

4

5

6.

YOUR TURN!

WICKED WITCH

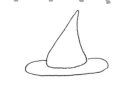

1

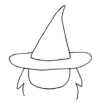

2

3

4

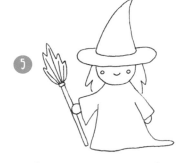

5

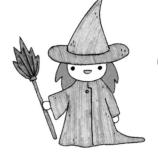

6

WIZENED WIZARD

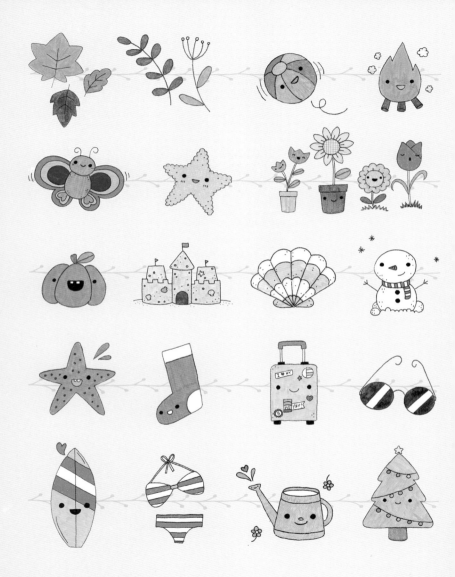

SEASONS AND HOLIDAYS

Winter, spring, summer, and fall.
With seasons come different holidays.
In this chapter, I will show you how to draw simple
items that represent each season, as well as some
of the holidays and festivities that go along with it.

FALL LEAVES

SKETCH THE LEAVES YOU SEE FALLING FROM THE TREES.

BEACH BALL

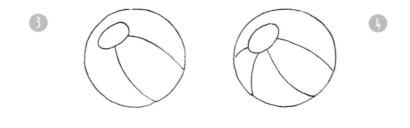

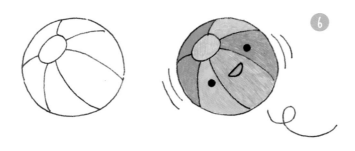

BURNING BONFIRE

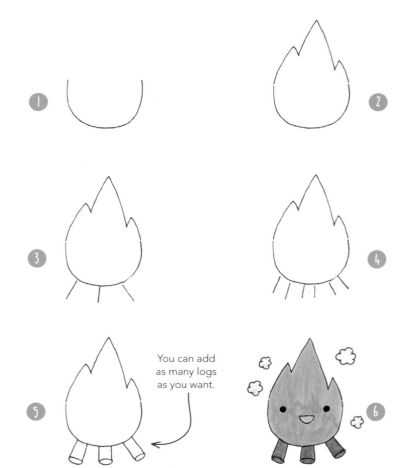

1

2

3

4

5 You can add as many logs as you want.

6

YOUR TURN!

BUTTERFLIES (AND BEES) IN YOUR STOMACH

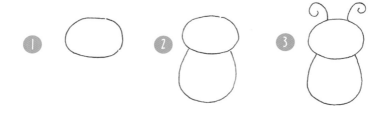

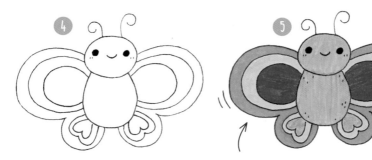

Decorate your butterfly's wings with any pattern you wish.

USE THE
BUTTERFLY'S
BODY TO CREATE
A BUZZING BEE!

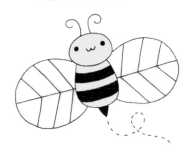

FLOWERS IN BLOOM

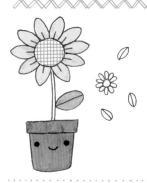

COME UP WITH A
BOUQUET TO GIVE
TO YOUR BESTIE!

TRICK OR TREAT

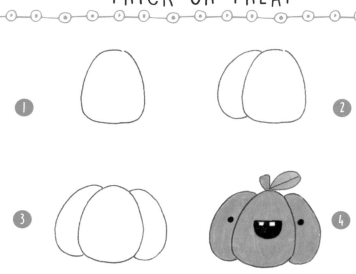

1

2

3

4

PUMPKIN HEADS

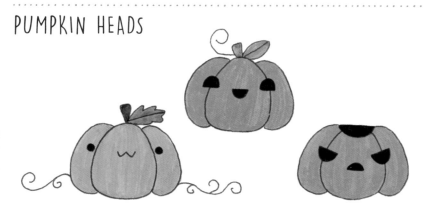

SKETCH A
SPOOKY TREAT!

A (SAND)CASTLE FIT FOR A KING

1

2

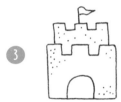

3

4

SUPER SANDCASTLES

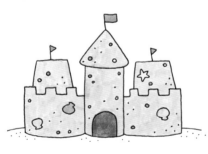

Adding some dots will give the sand texture.

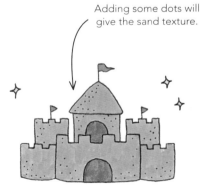

SEASHELLS

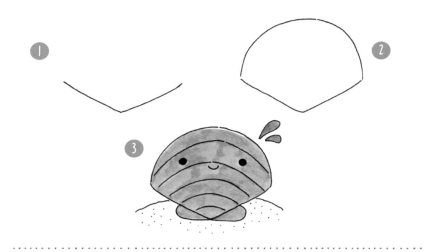

1
2
3

A TRIO OF SHELLS

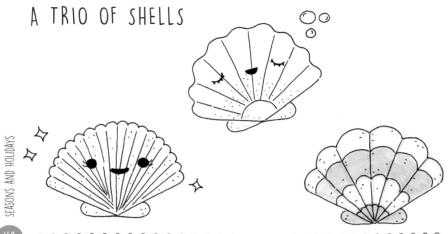

STYLE UP
YOUR SHELL!

FROSTY THE SNOWMAN

1

2

3

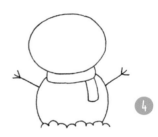

4

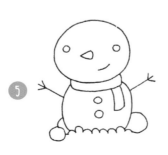

5

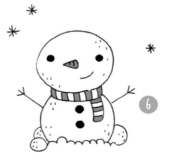

6

STARFISH

○ ○

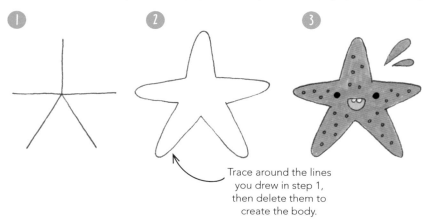

Trace around the lines you drew in step 1, then delete them to create the body.

A GALAXY OF STARFISH

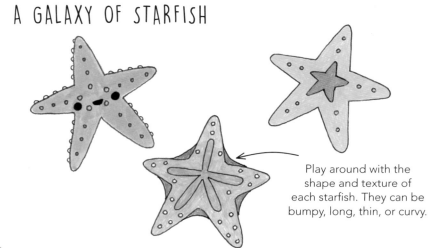

Play around with the shape and texture of each starfish. They can be bumpy, long, thin, or curvy.

○ ○

TEST YOUR
STARFISH SKILLS!

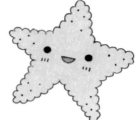

CHRISTMAS STOCKINGS

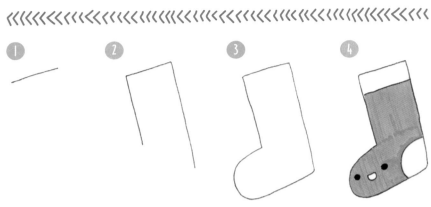

1 2 3 4

..

HANG YOUR STOCKINGS BY THE FIRE

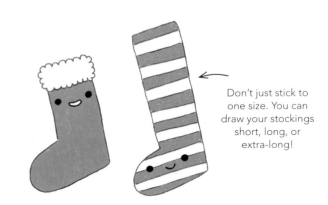

Don't just stick to one size. You can draw your stockings short, long, or extra-long!

CREATE AND COLOR!

LIVING OUT OF A SUITCASE

× ×

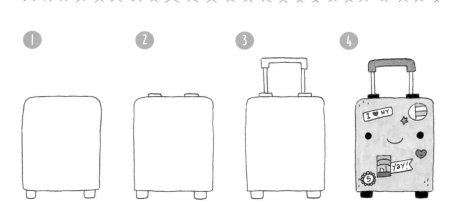

OFF WE GO!

Create movement
by adding
curved lines.

× ×

ROLL WITH IT!

THROW SHADE TO THE SUN

CREATE YOUR COOLEST PAIR OF SUNNIES!

SURF'S UP!

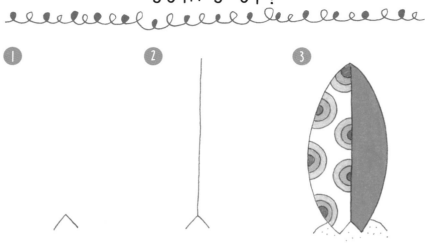

1 2 3

A BOARD FOR EVERY OCCASION

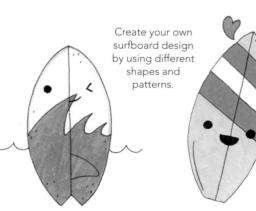

Create your own surfboard design by using different shapes and patterns.

Or why not personalize it by adding your name?

NOW IT'S
YOUR
TURN!

ITSY BITSY BIKINI

1

2

3

4

5

Go for polka dots, stars, or stripes to make your bathing costume stand out!

DESIGN YOUR OWN BIKINI!

WATERING CAN

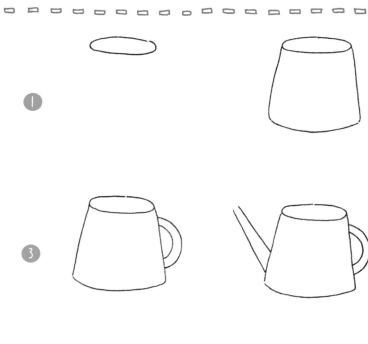

1

2

3

4

5

6

OH, CHRISTMAS TREE!

 1

 2

3

4

TWINKLE, TWINKLE

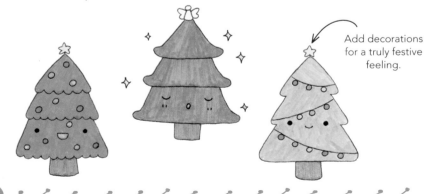

Add decorations for a truly festive feeling.

NOW DRAW IT!

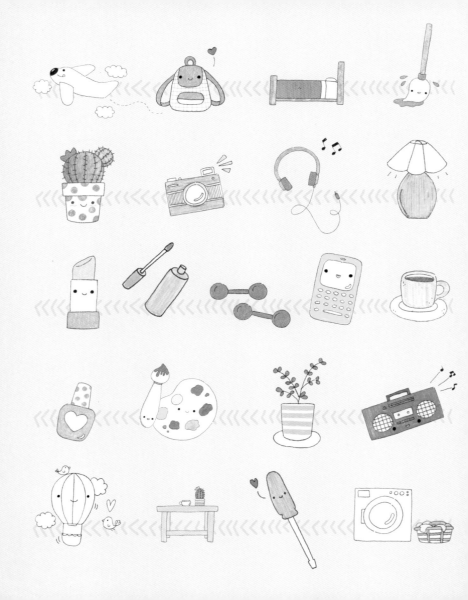

DAILY LIFE

Some of my favorite things to doodle are the items lying around at home. Sketching furniture, cutlery, or even the things inside your bag is a great way of practicing. In this chapter, I share quick and easy steps on how to doodle random everyday objects that you can use in your planners and journals.

TAKE FLIGHT

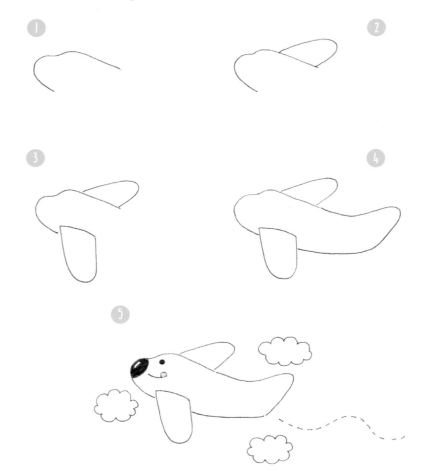

BAG OF TRICKS

1
2
3
4
5

NOW
DRAW
IT!

AND SO TO BED...

1

2

3

4

5

6

YOUR TURN!

A CLEAN SWEEP

1

2

3

A CLEAN SWEEP

CACTUS

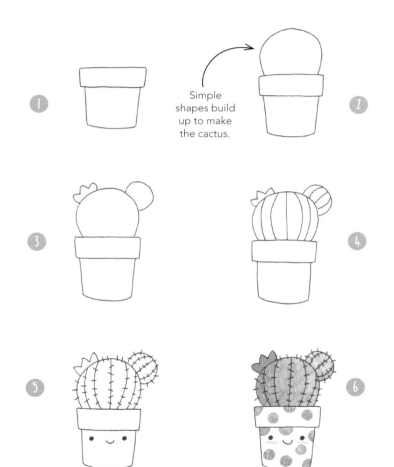

Simple shapes build up to make the cactus.

△ ▽ △ ▽ △ ▽ △ ▽ △ ▽ △ ▽ △ ▽ △ ▽ △ ▽ △ ▽ △ ▽ △ ▽ △ ▽ △ ▽

HAVE A GO!

▽ △ ▽ △ ▽ △ ▽ △ ▽ △ ▽ △ ▽ △ ▽ △ ▽ △ ▽ △ ▽ △ ▽ △ ▽

GREEN THUMBS

Create different plant pots by
drawing shapes such as hexagons,
squares, and cylinders.

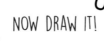

NOW DRAW IT!

PICTURE PERFECT

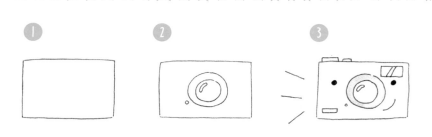

CLICK, CLICK, FLASH

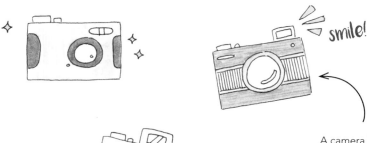

smile!

A camera has three basic parts— a lens, flash, and buttons!

MUSIC TO MY EARS

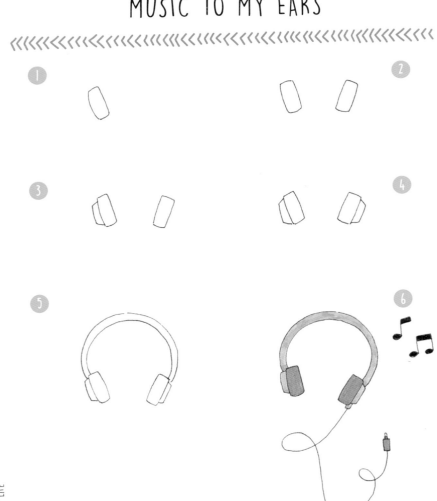

A RAY OF LIGHT

IT'S YOUR
TURN TO
DOODLE!

LUSCIOUS LIPS

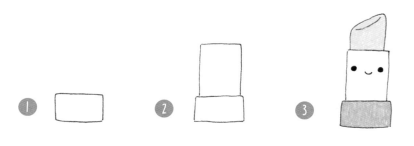

SEALED WITH A KISS

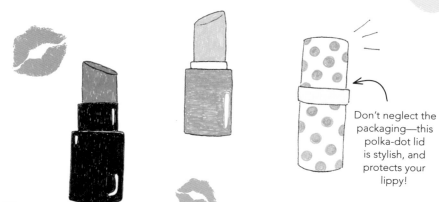

Don't neglect the packaging—this polka-dot lid is stylish, and protects your lippy!

PRACTICE
DIFFERENT
COLOR PALETTES!

KISS AND MAKE—UP

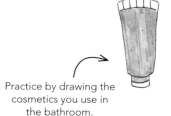

Practice by drawing the cosmetics you use in the bathroom.

CALL ME!

HOLD THE PHONE

Most phones are touch screen now, but you can still draw a keypad to add variety.

CUP OF JOE

1

2

3

FULL TO THE BRIM

Change the shape of the container by creating different line strokes—make them curvy, straight, or slanted.

PRETTY AND POLISHED

BOTTLE IT UP

Mix and match the top and bottom of your bottles to create new shapes.

NOW DRAW IT!

PLAYING WITH COLOR

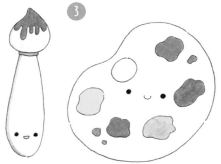

CREATE YOUR OWN COLOR PALETTE!

TUNE IN

 1

 2

 3

 4

 5

 6

HAVE A GO!

TABLE TALK

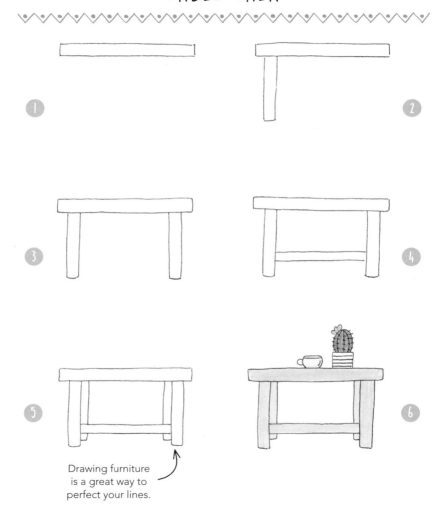

1

2

3

4

5

6

Drawing furniture is a great way to perfect your lines.

HAVE A GO!

TEA PARTY

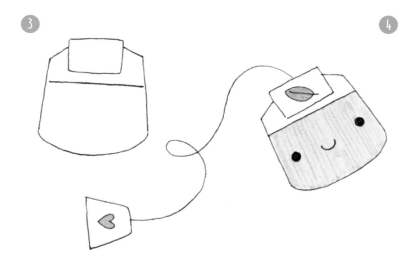

WHAT'S YOUR FAVORITE HERBAL TEA?

TOOLS OF THE TRADE

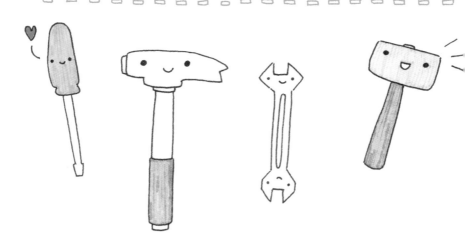

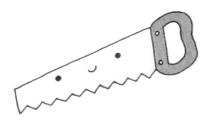

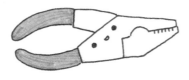

TOOLS OF THE TRADE

WASHER DRYER

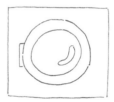
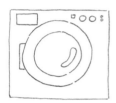

NOW DRAW IT!

WHATEVER THE WEATHER

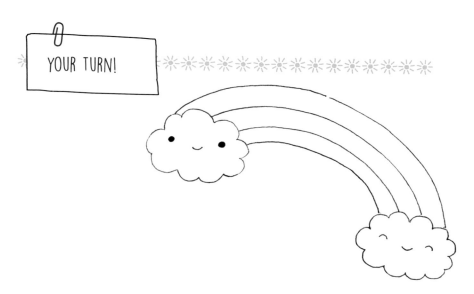

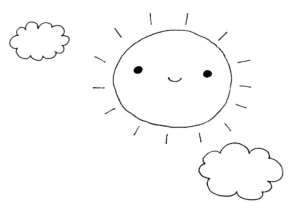

PULL YOUR WEIGHT

1

 2

3

 4

5

 6

△ • ▽ **TRY IT YOURSELF!** △ • ▽ • △ • ▽ • △ • ▽ • △ • ▽

For Quarto:

Editor: Kate Burkett
Art Editor: Martina Calvio
Designer: Karin Skånberg
Publisher: Samantha Warrington

QUAR.KWAI

FOR MY PARENTS